COLOMBIA
Sketch Coloring Book

BEST IN TRAVEL 2017

-

TOP 10 COUNTRIES YOU DO NOT MISS IN 2017
(Volume 2)

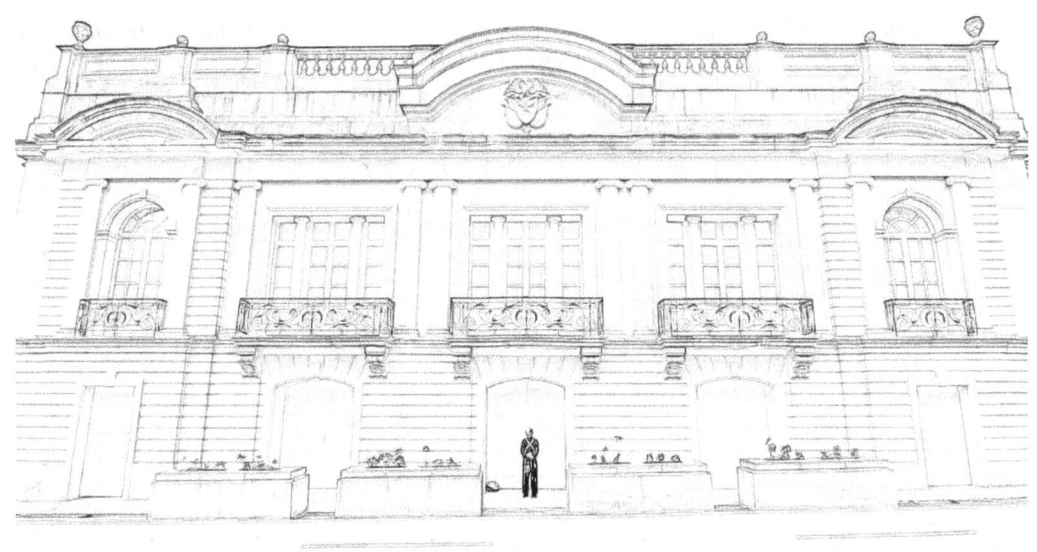

Anthony Hutzler

Copyright: Published in the United States by Anthony Hutzler
Published January 2017

All rights reserved. No part of this publication may be reproduced, stored in retrieval system, copied in any form or by any means, electronic, mechanical, photocopying, recording or otherwise transmitted without written permission from the publisher. Please do not participate in or encourage piracy of this material in any way. You must not circulate this book in any format. Anthony Hutzler does not control or direct users' actions and is not responsible for the information or content shared, harm and/or actions of the book readers.

Front of House of Narino, official home and principal workplace of the President

A small bell tower on the Monserate Bogota hill.

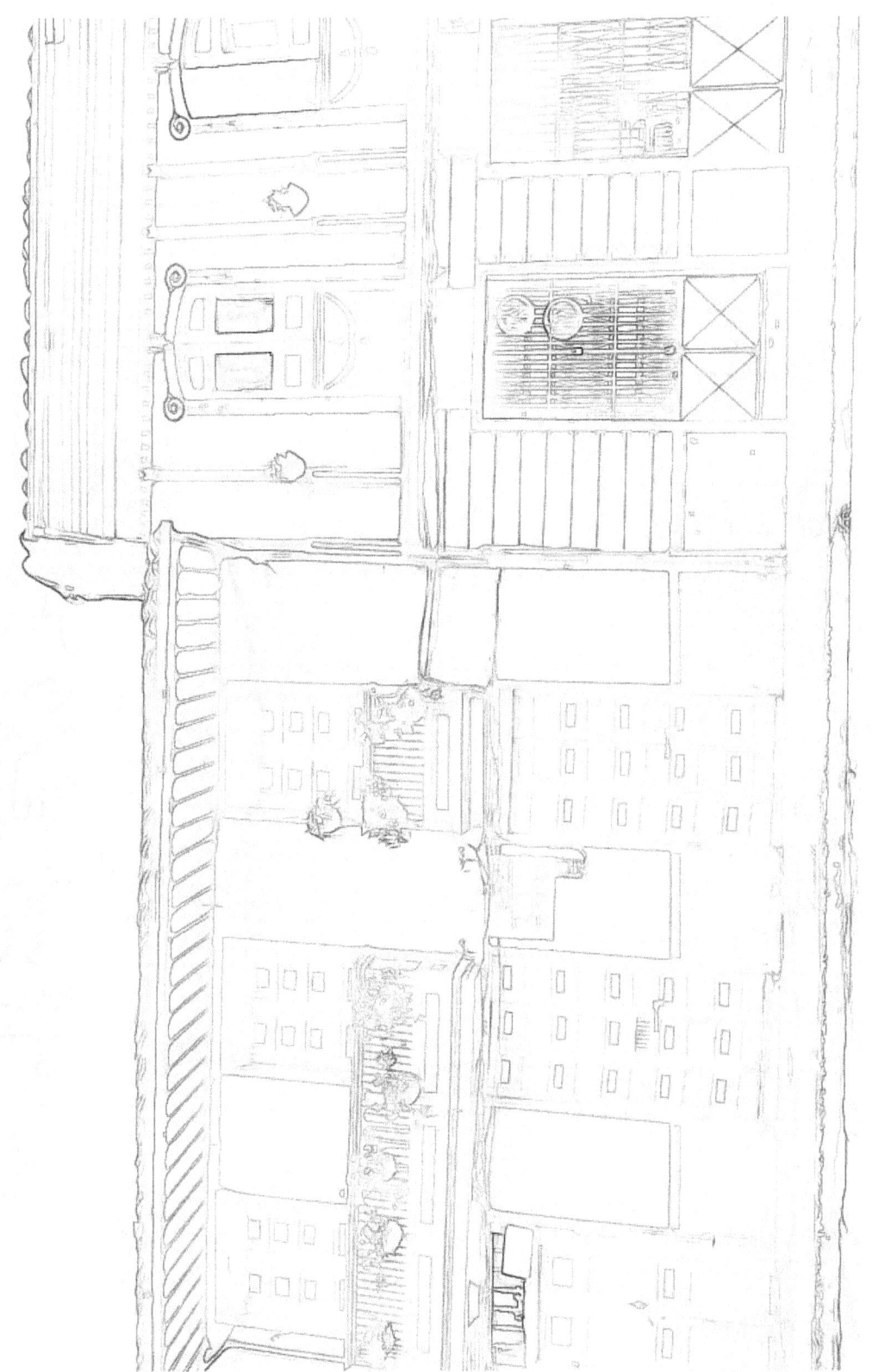

Colorful colonial architecture in Salento

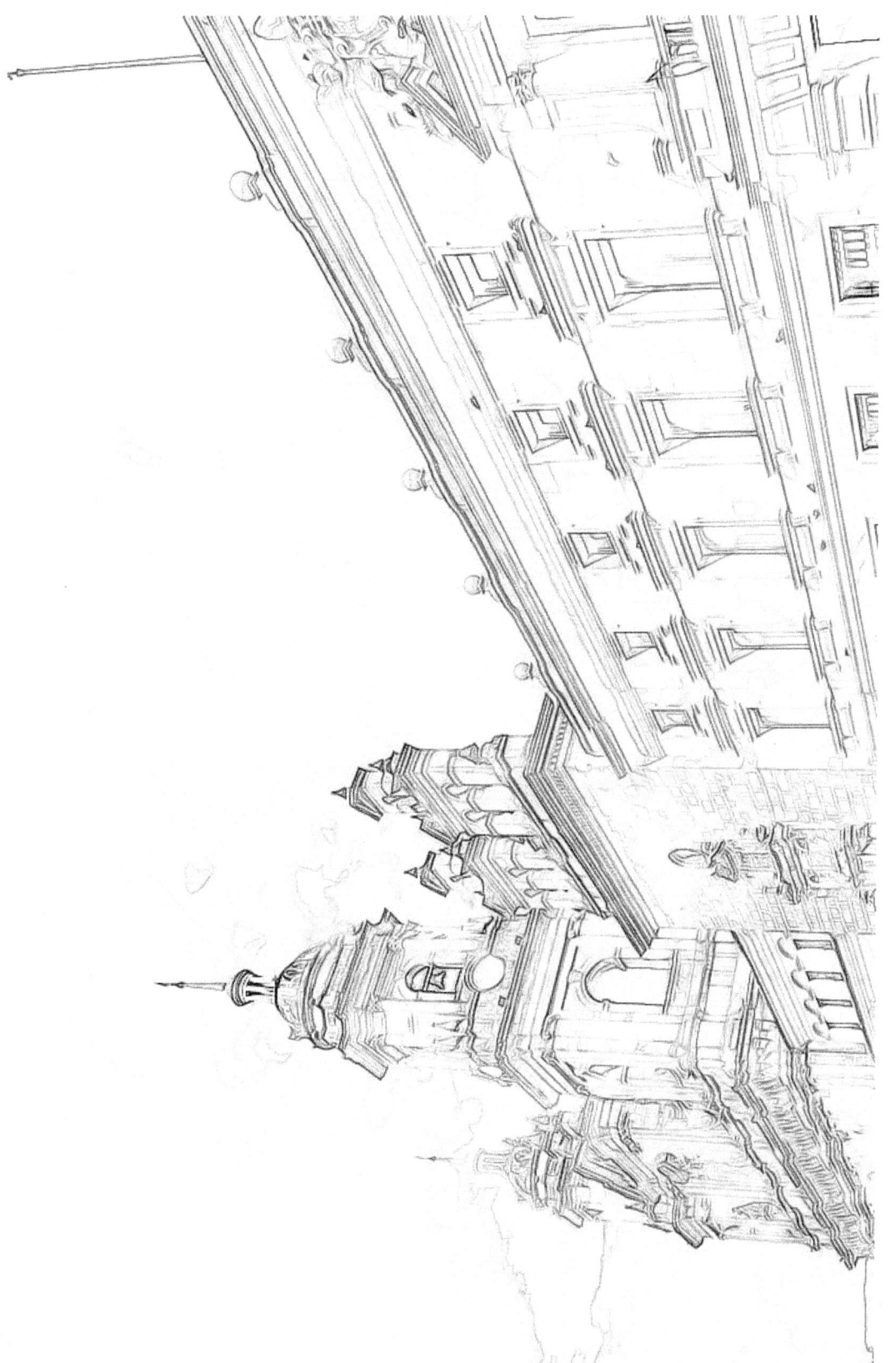

Bolivar Square and the Cathedral in Bogota

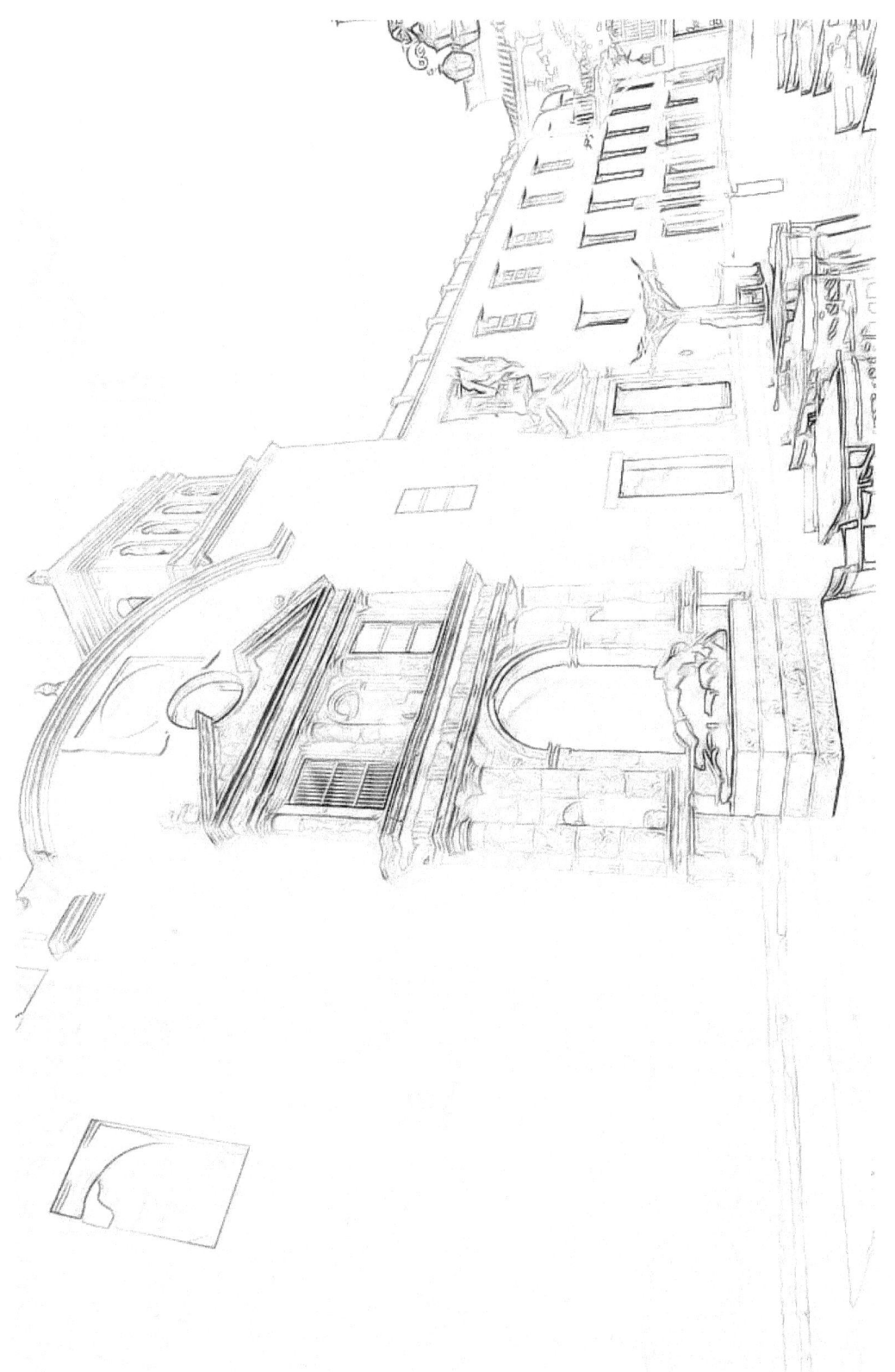

Statue by Fernando Botero in Santo Domingo plaza by a yellow church in Cartagena

House of terrakota

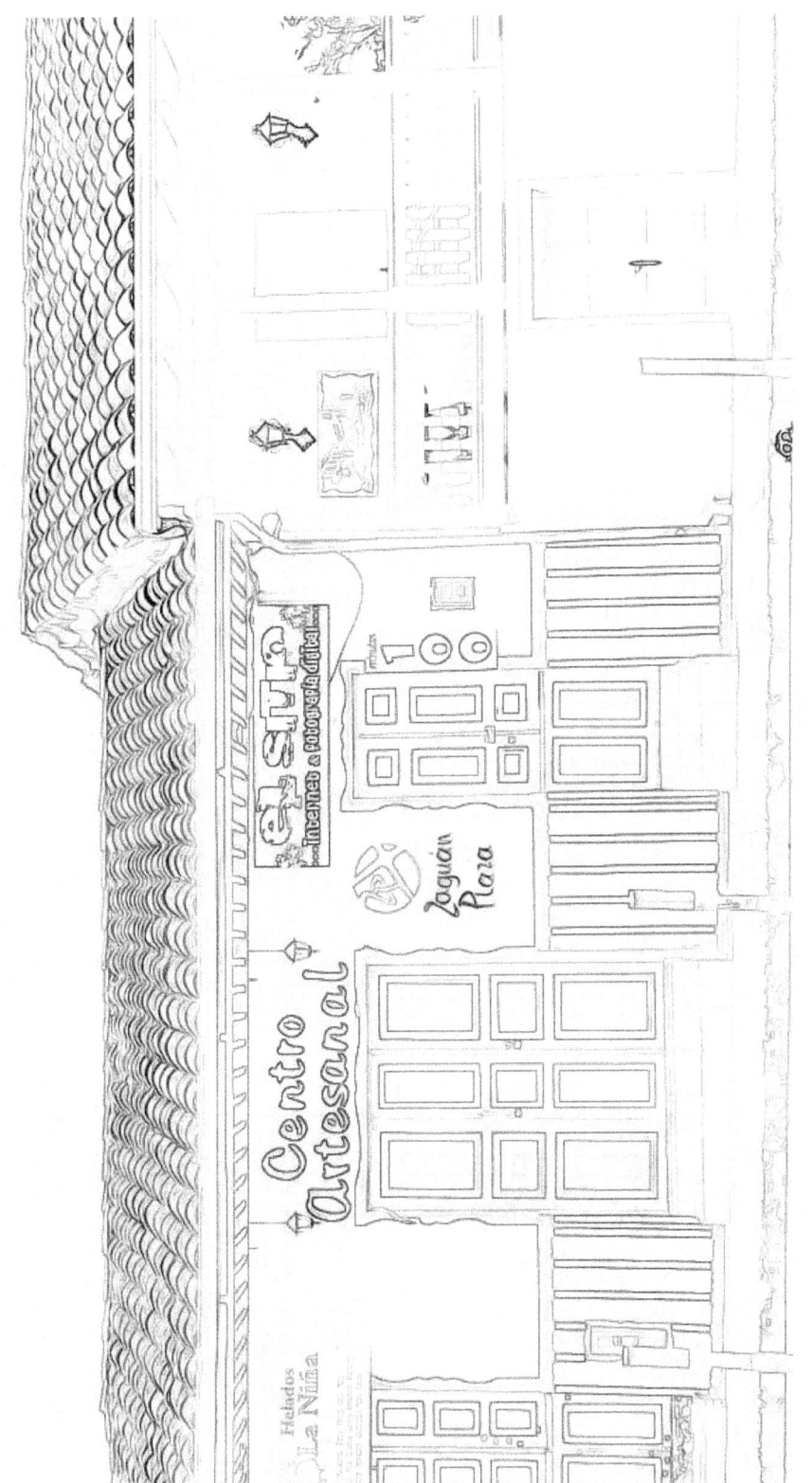

Colorful architecture in Salento

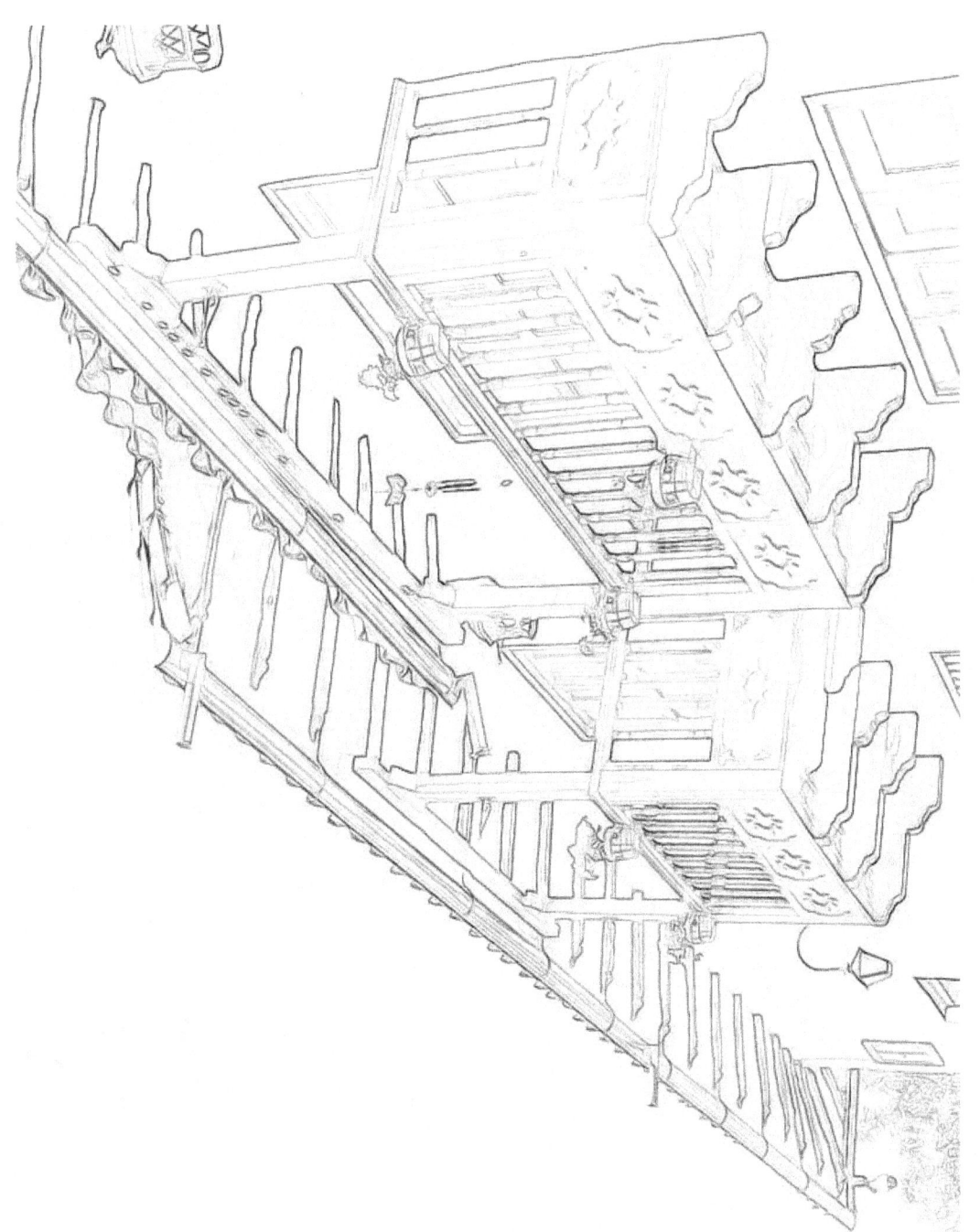

Colonial houses in Colombia

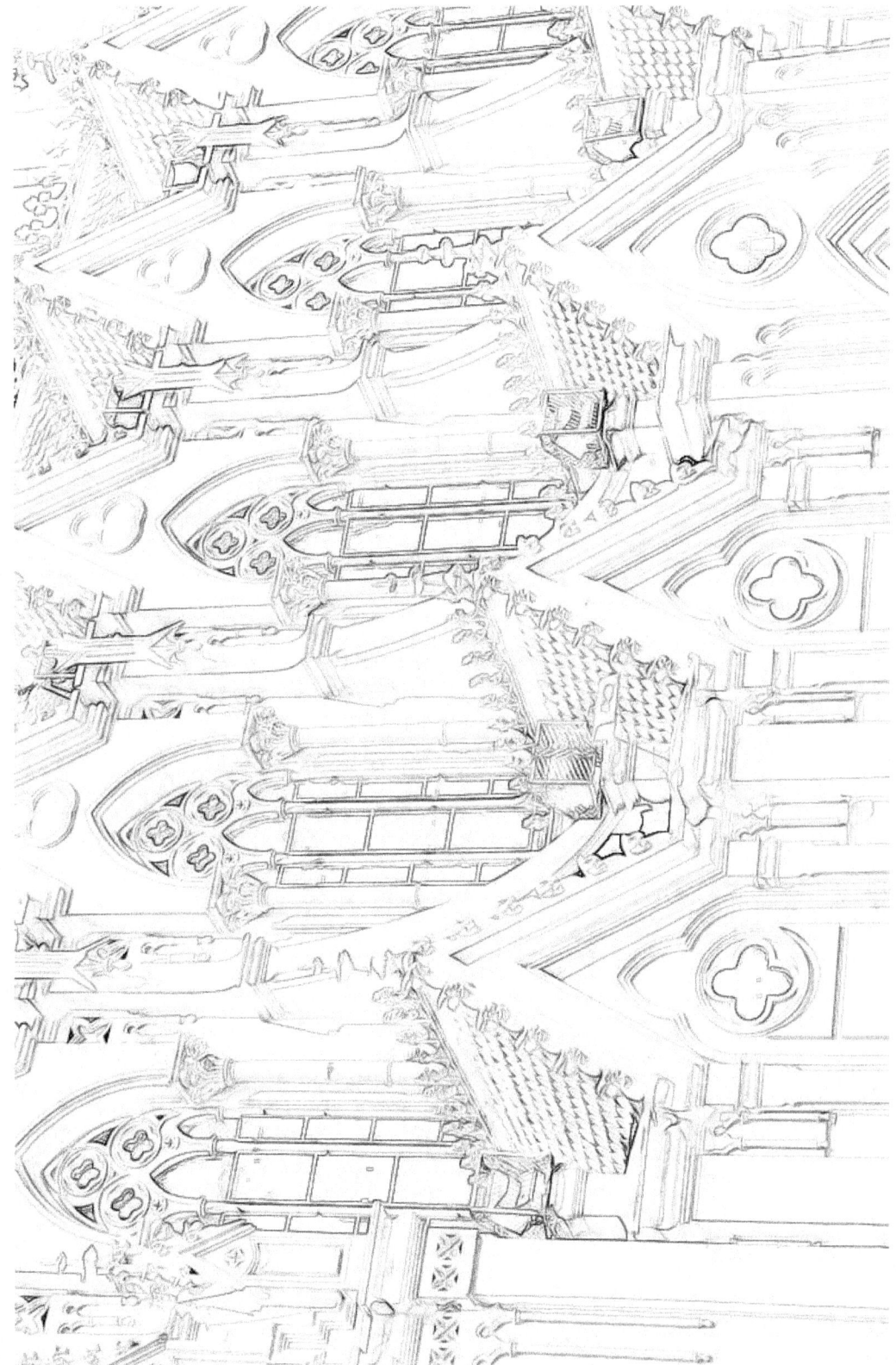

Details of the church known as La Ermita in Cali

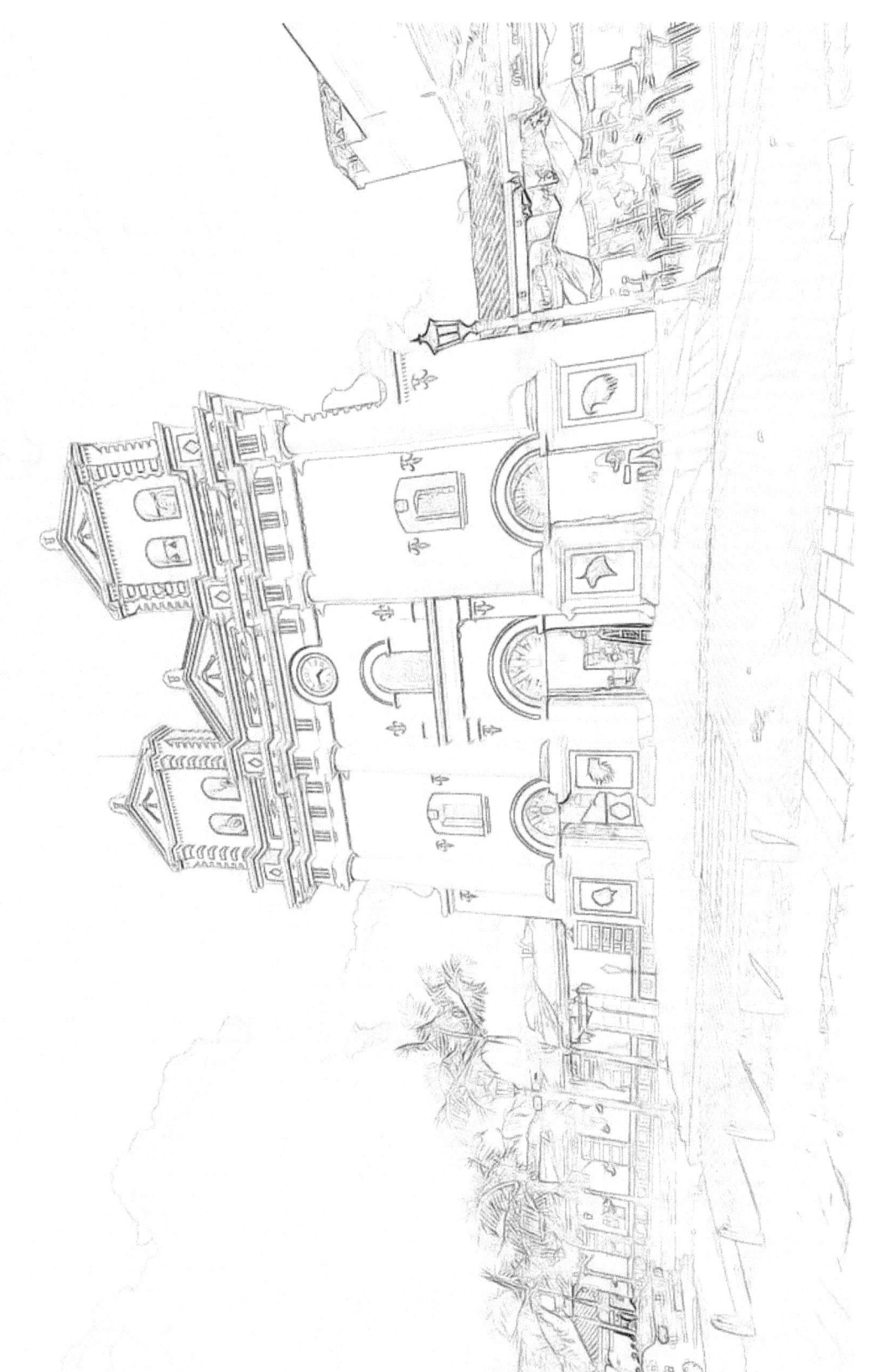

Colorful streets and decorated houses of Guatape city near Medellin

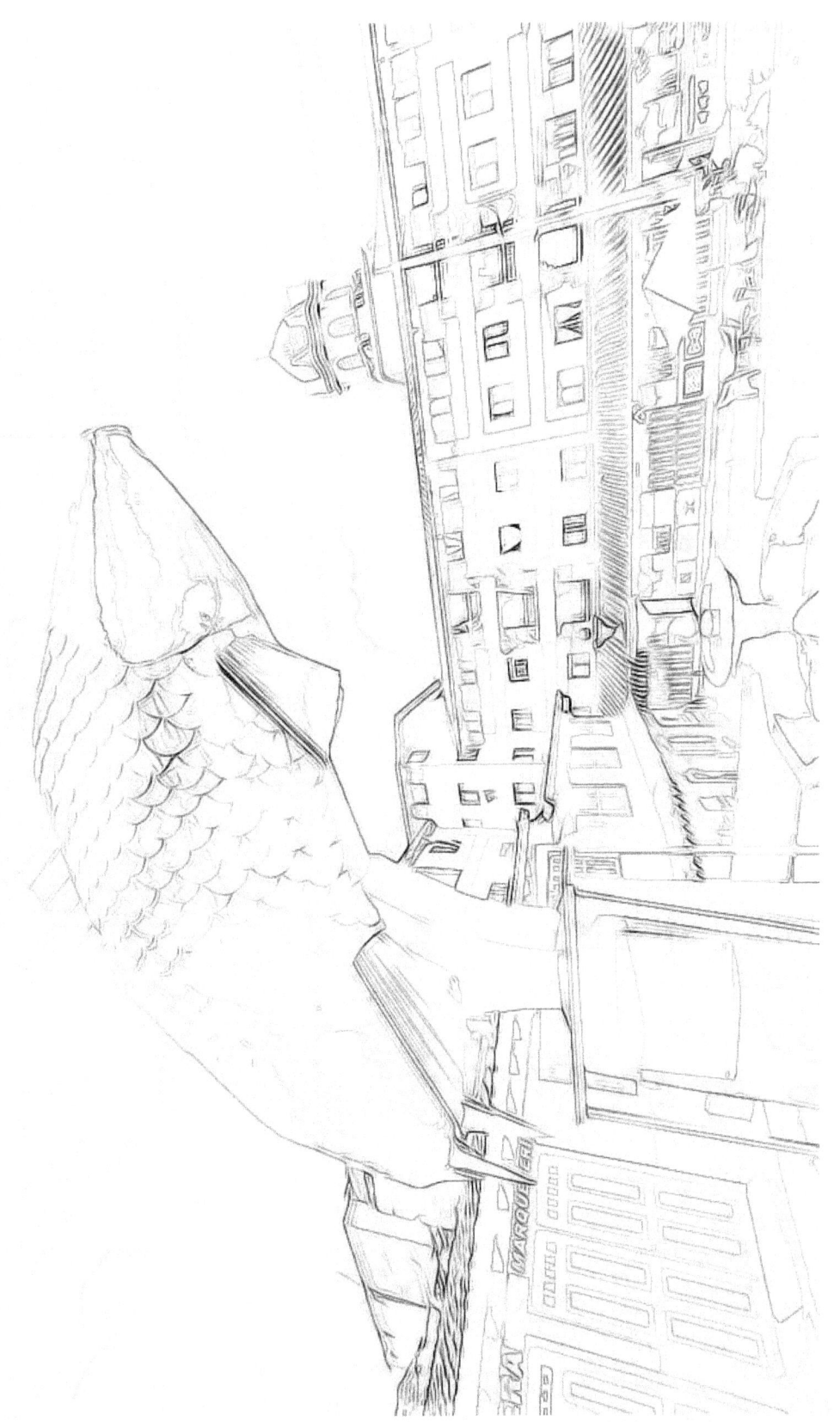

Colorful streets and decorated houses of Guatape city near Medellin, Antioquia

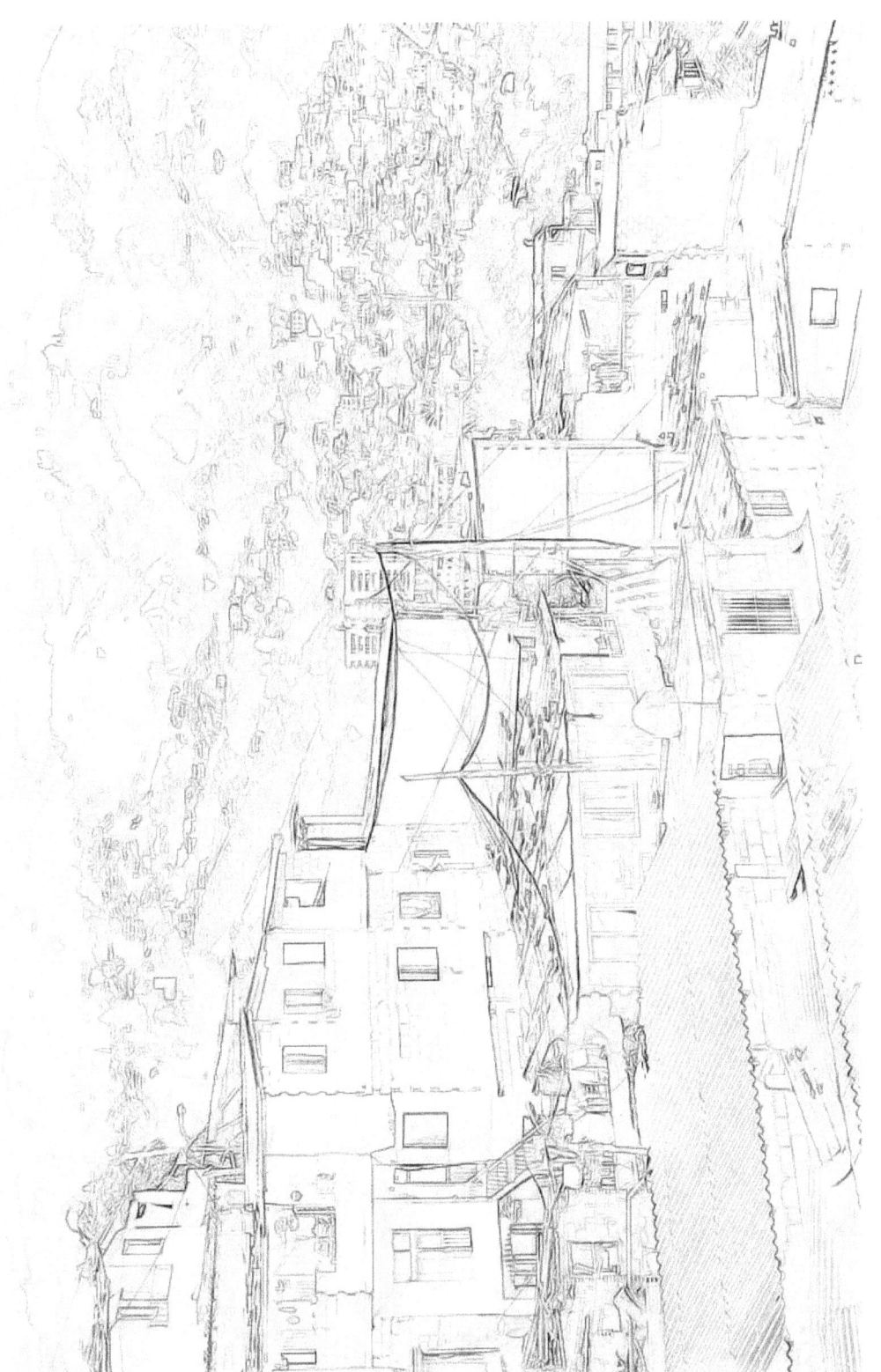

The most dangerous part of the city, turned into a zone of Contemporary Art, Medellin

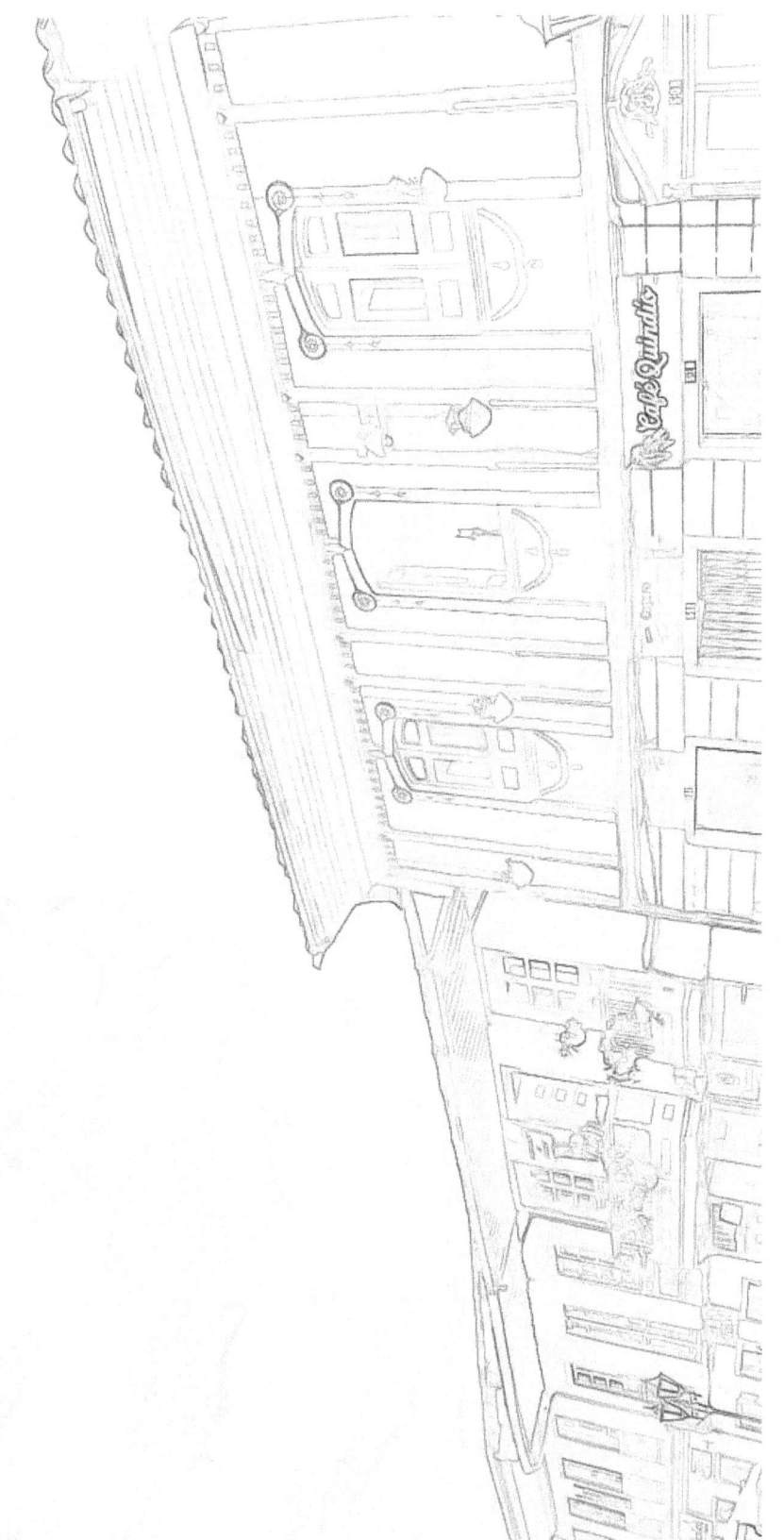

View of storefronts in Salento

Church in Salento

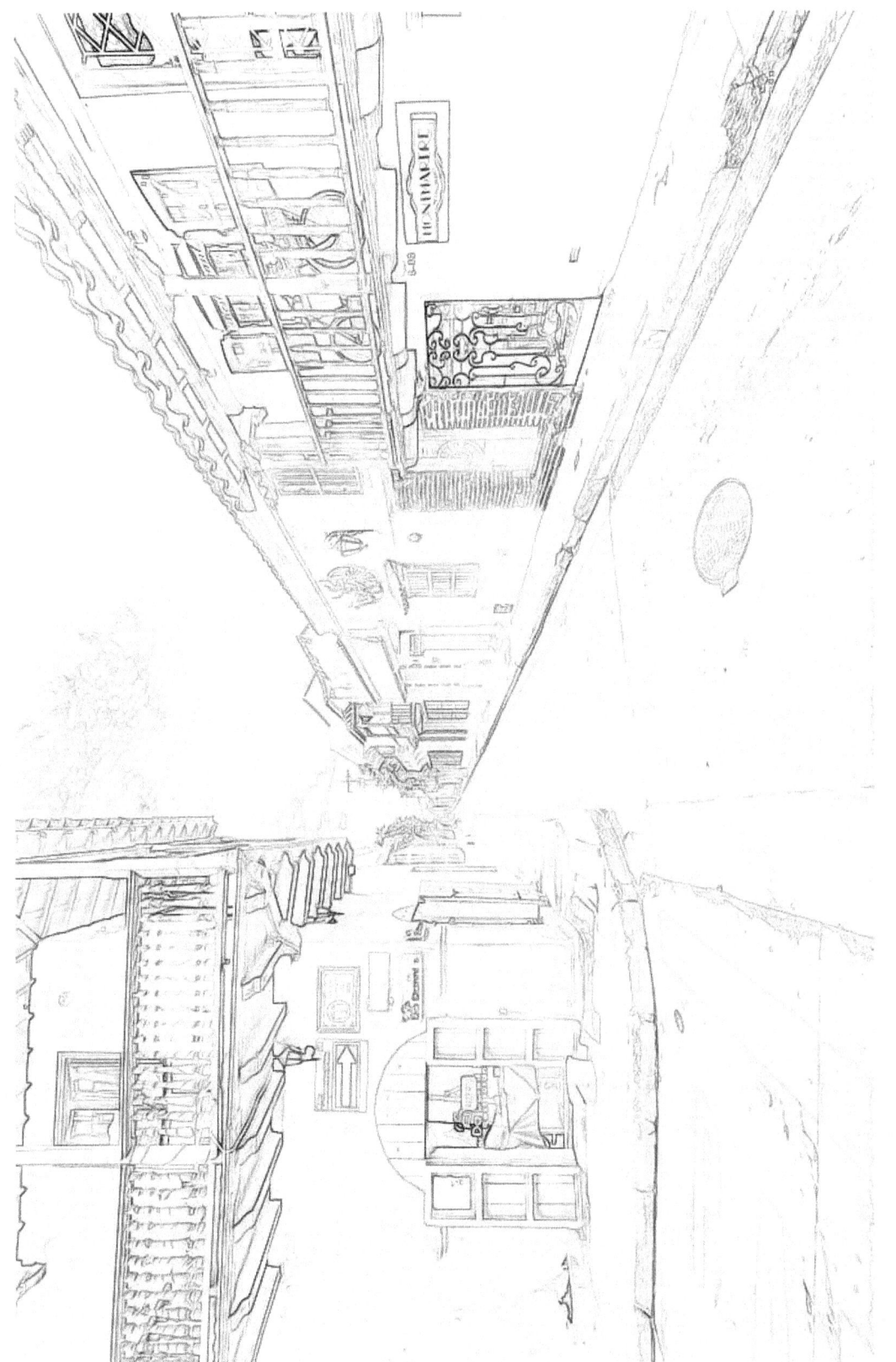

The old town of Cartagena with its unique architecture.

Traditional Hut Adornments in Lost City

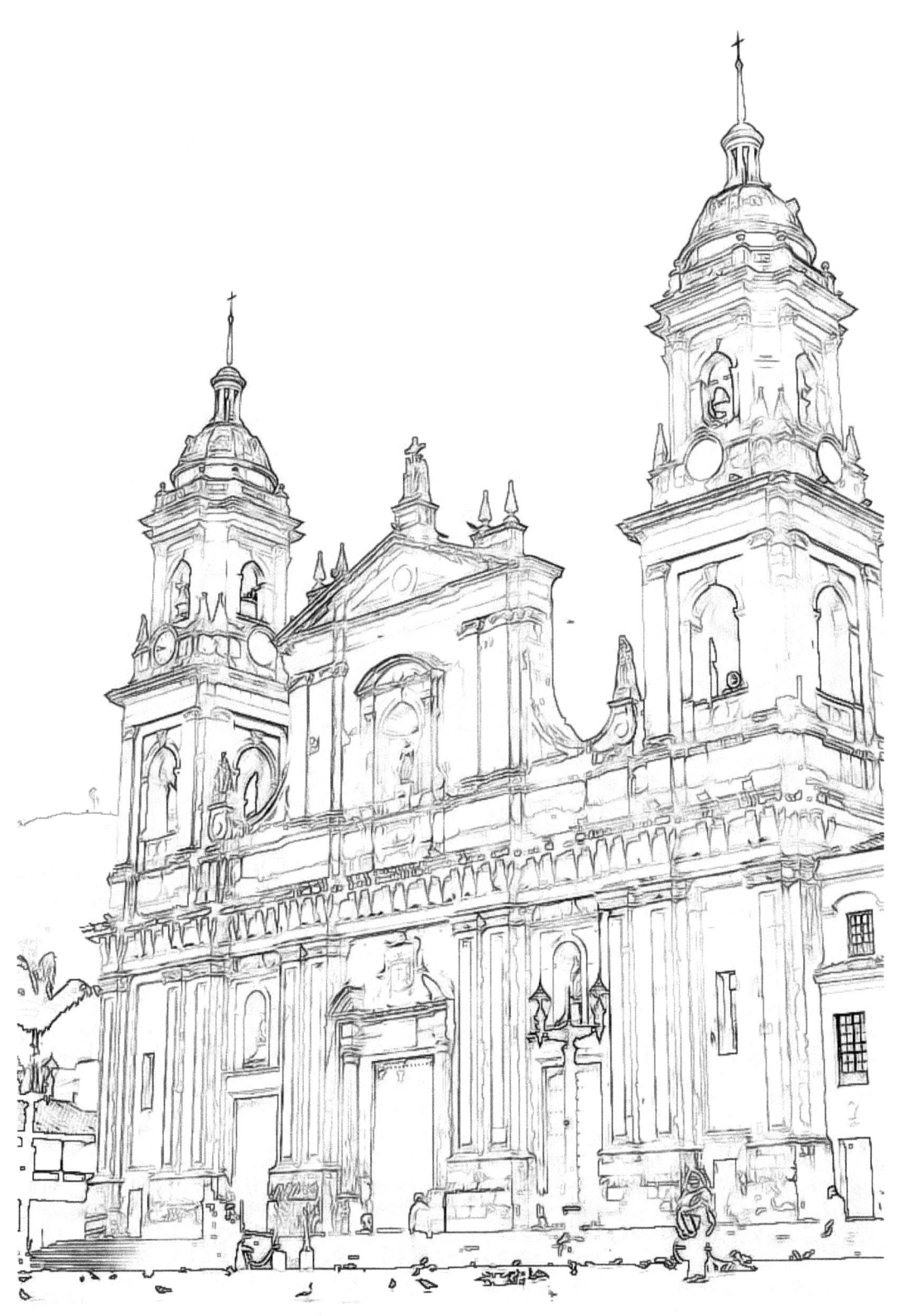

Bogota building

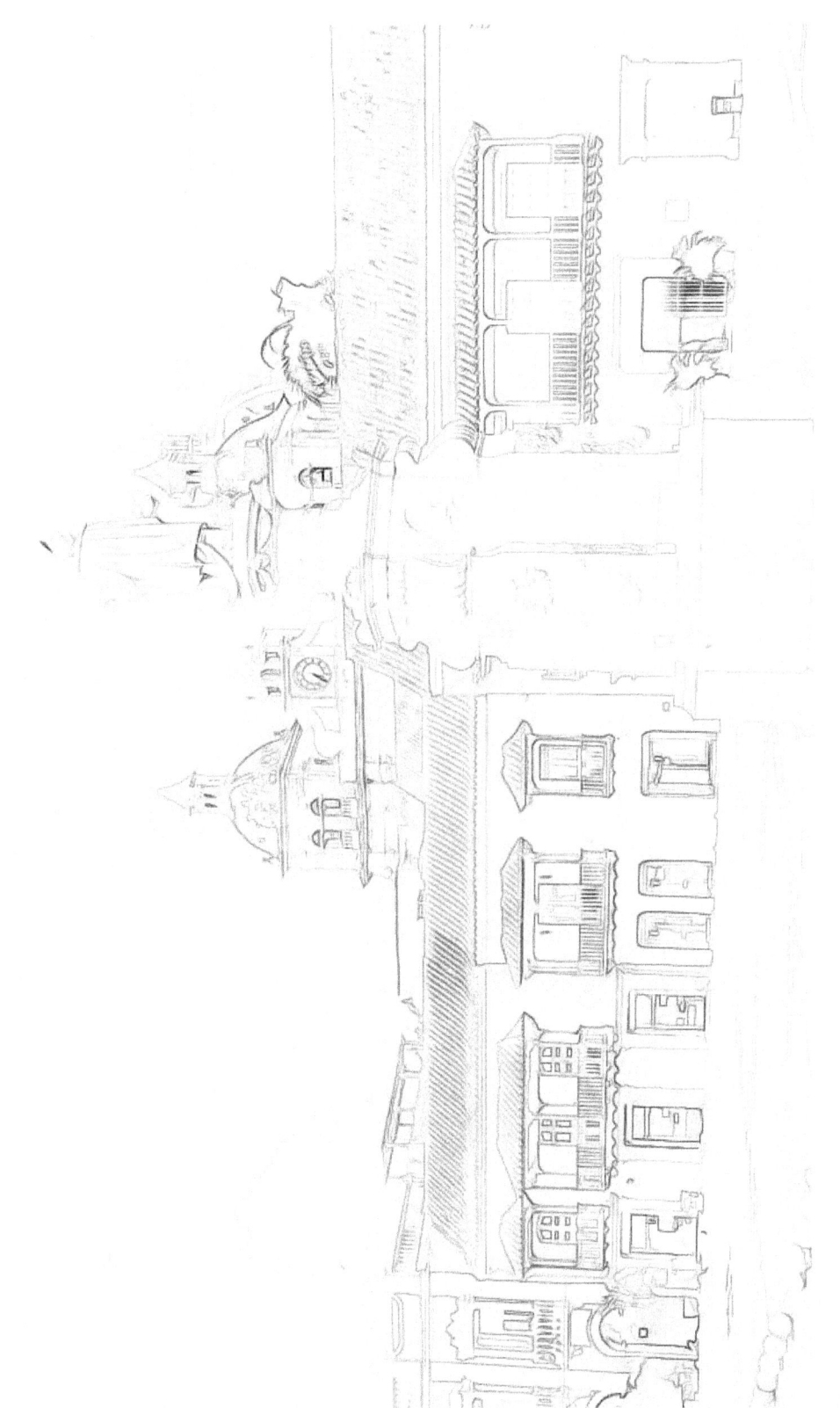

View of the Aduana Plaza in the historic old center of Cartagena

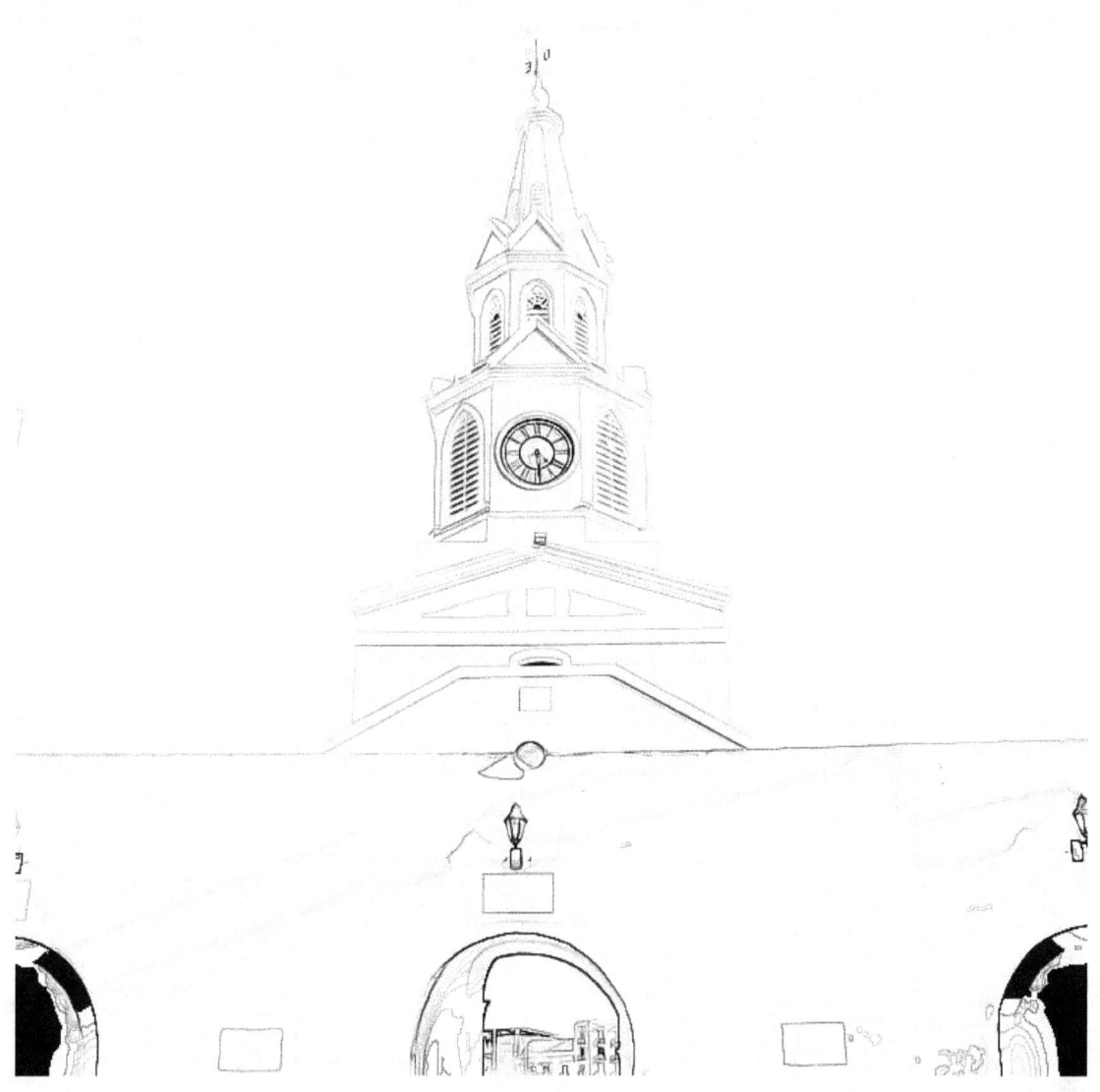

Clock tower walled city Cartagena

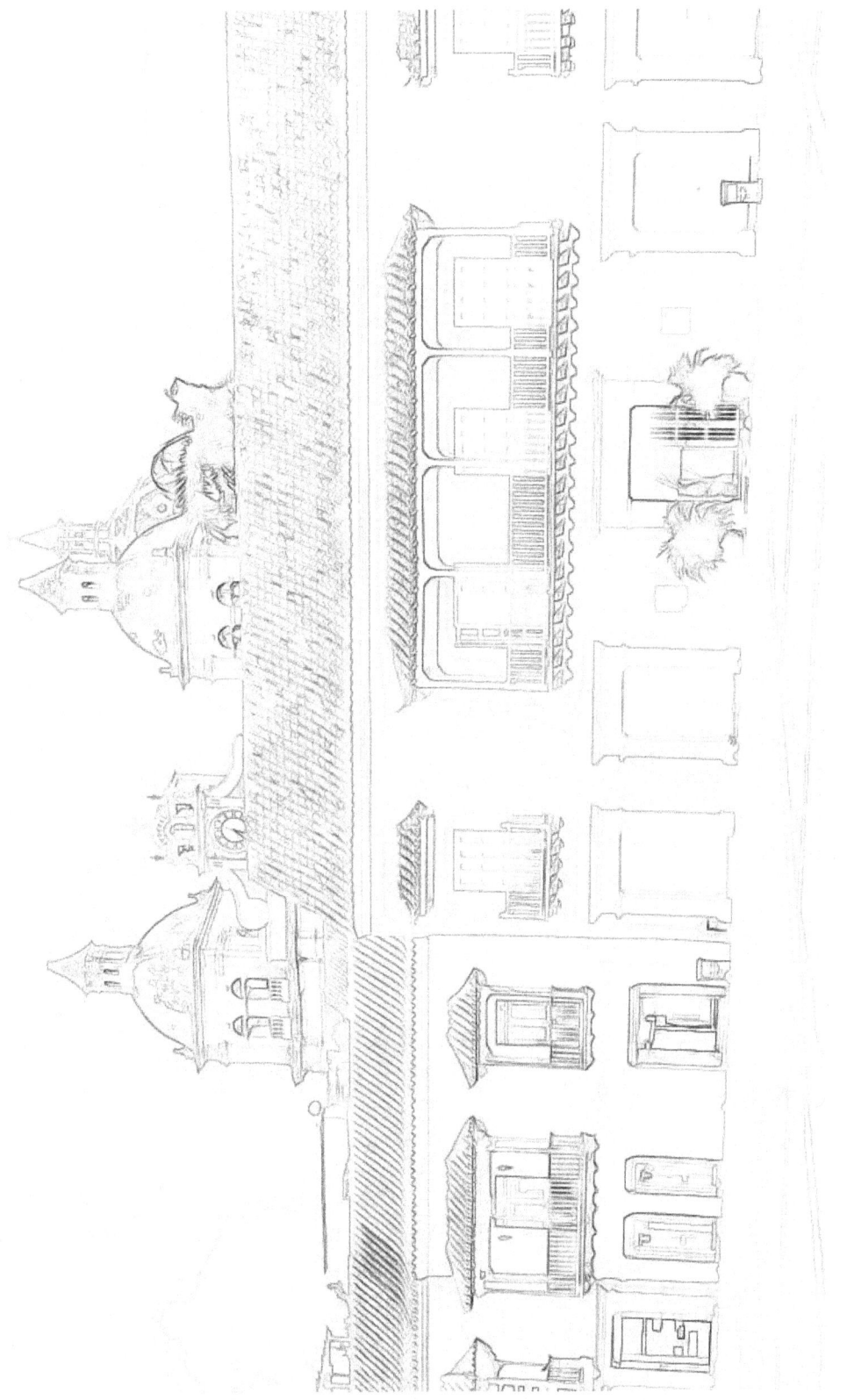

Plaza de la Aduana in Cartagena

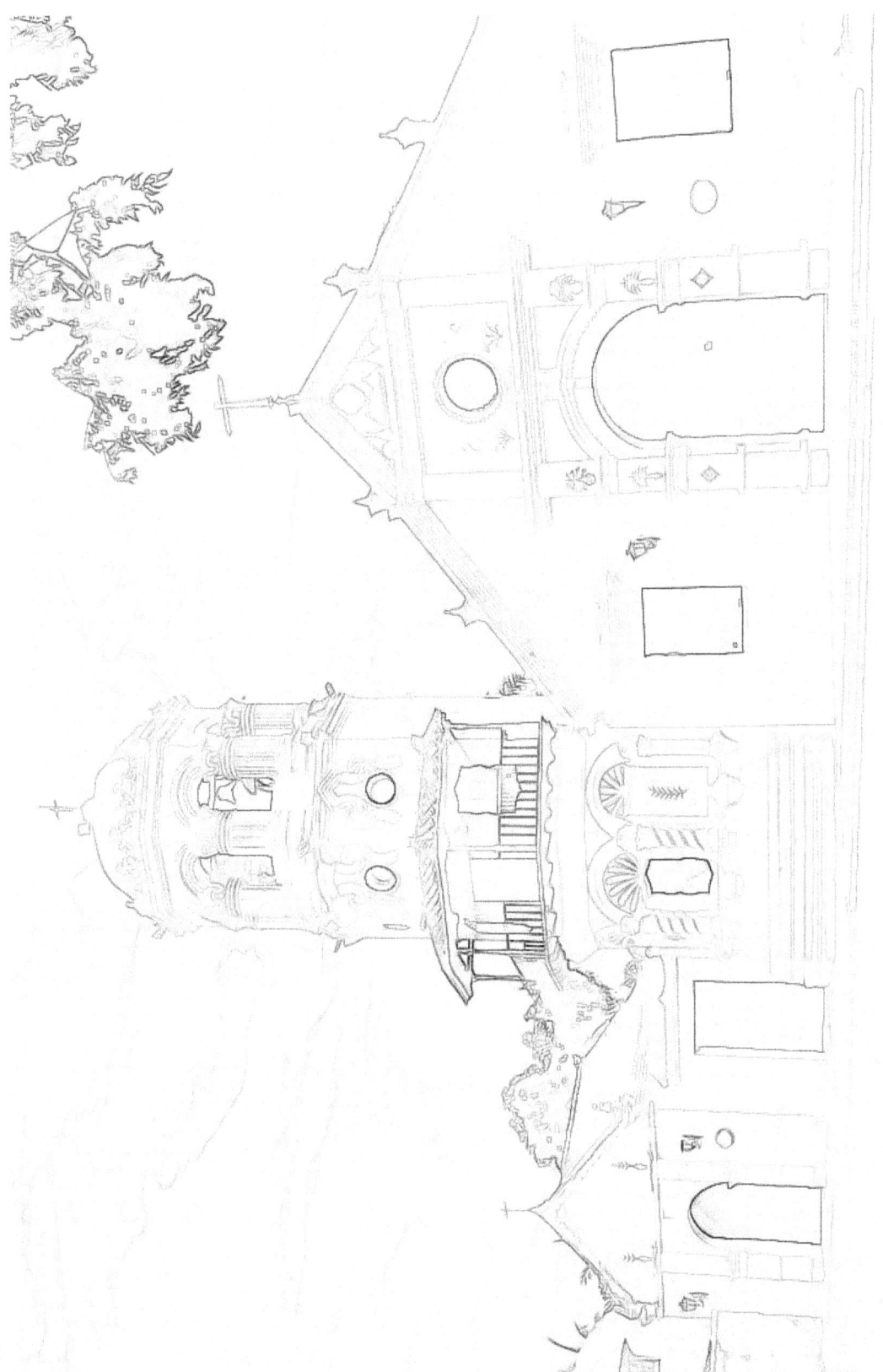

Historic Santa Barbara Church in Mompox

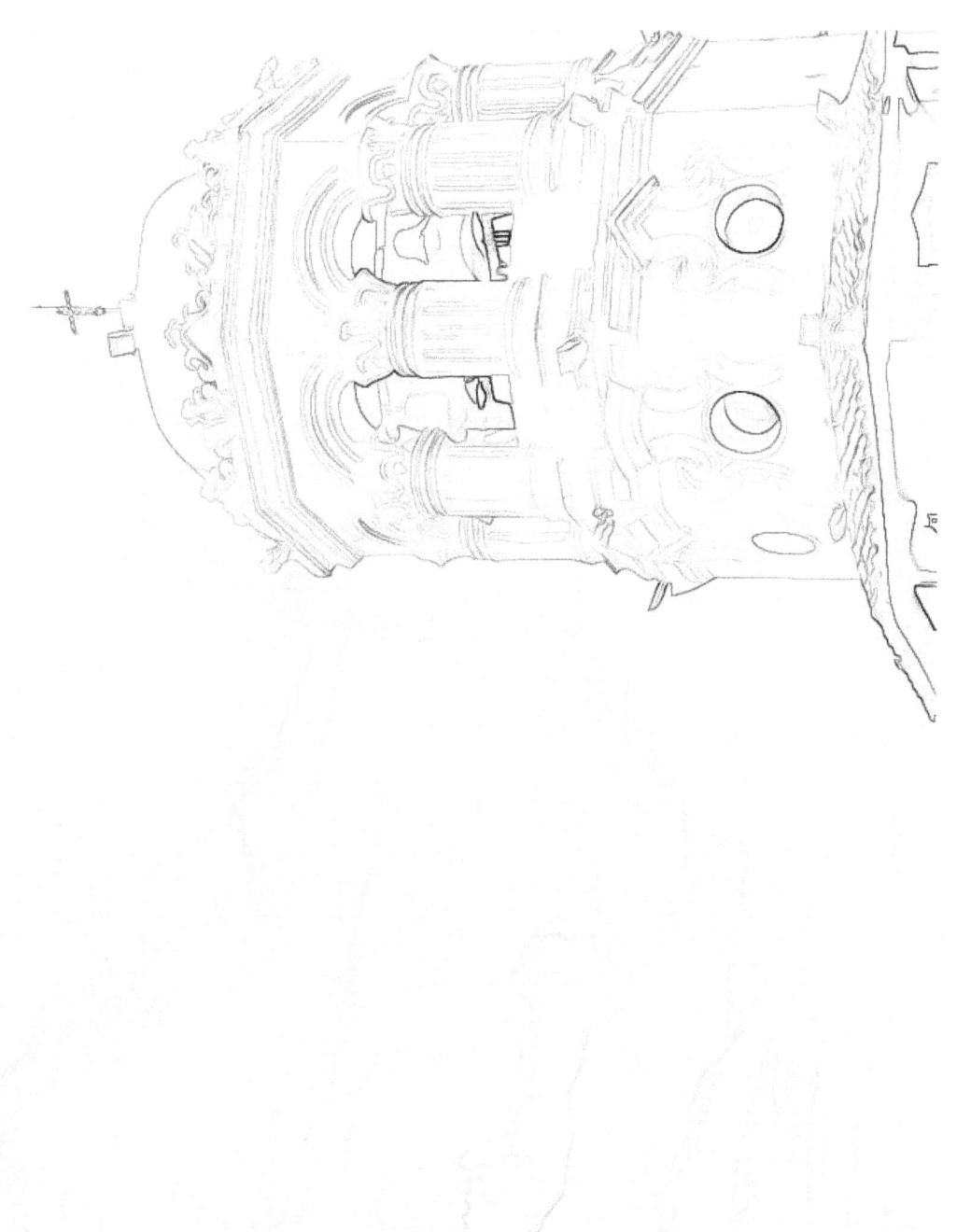

View of the spire of the Santa Barbara church in Mompox

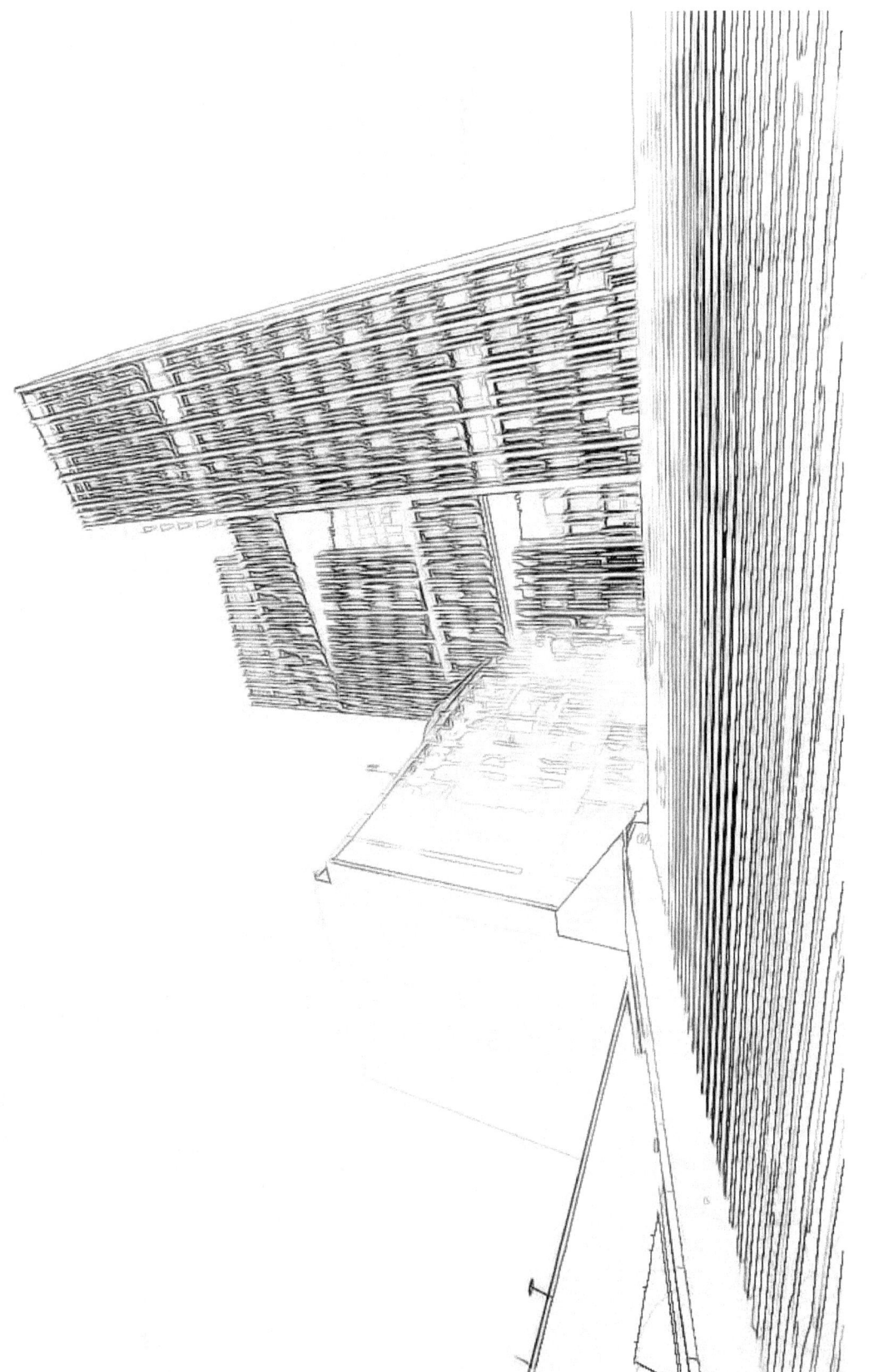

Medellin, Colombia: modern building in the center of the city

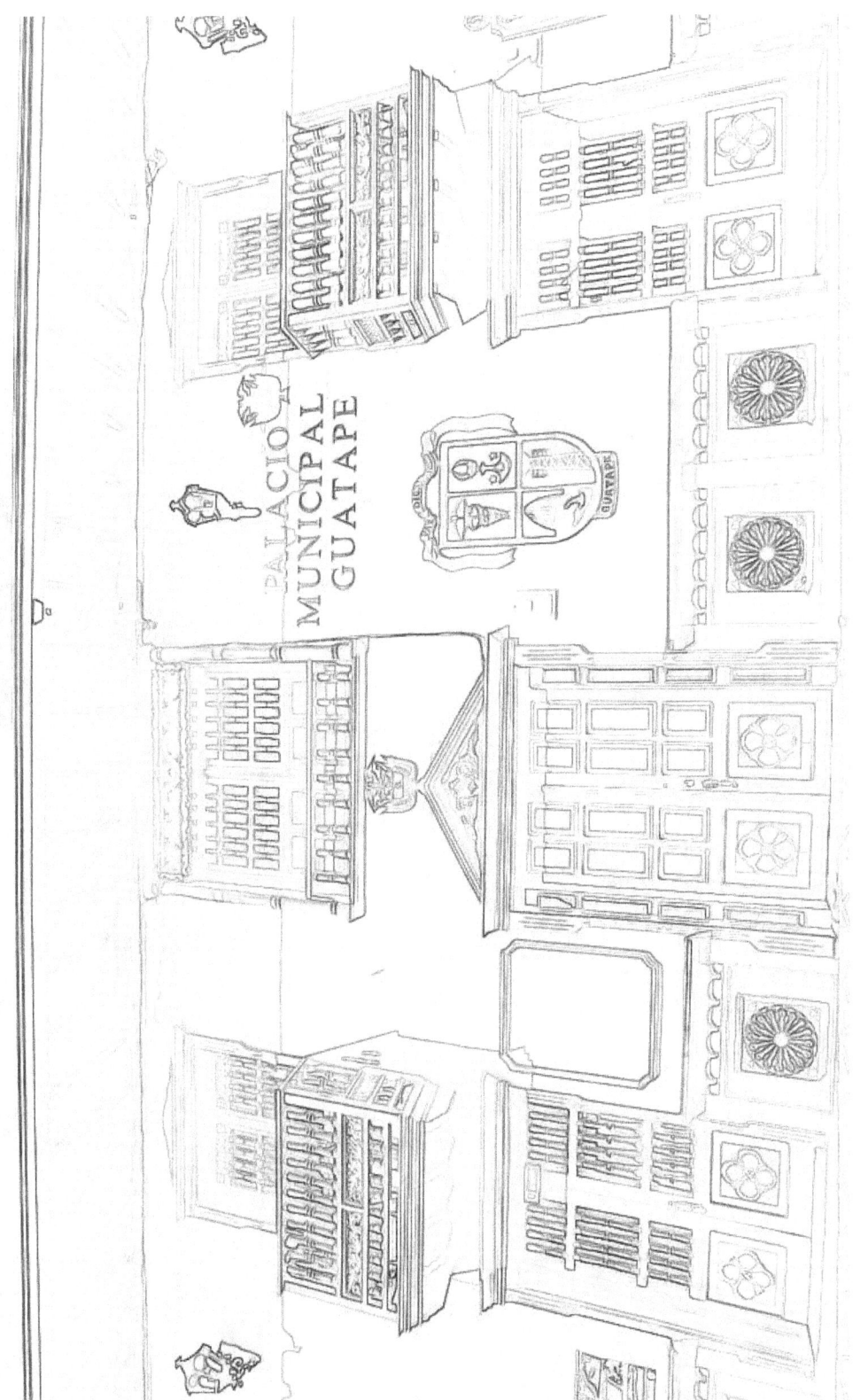

Guatape: the colourful colonial architecture of the city hall building in the town centre

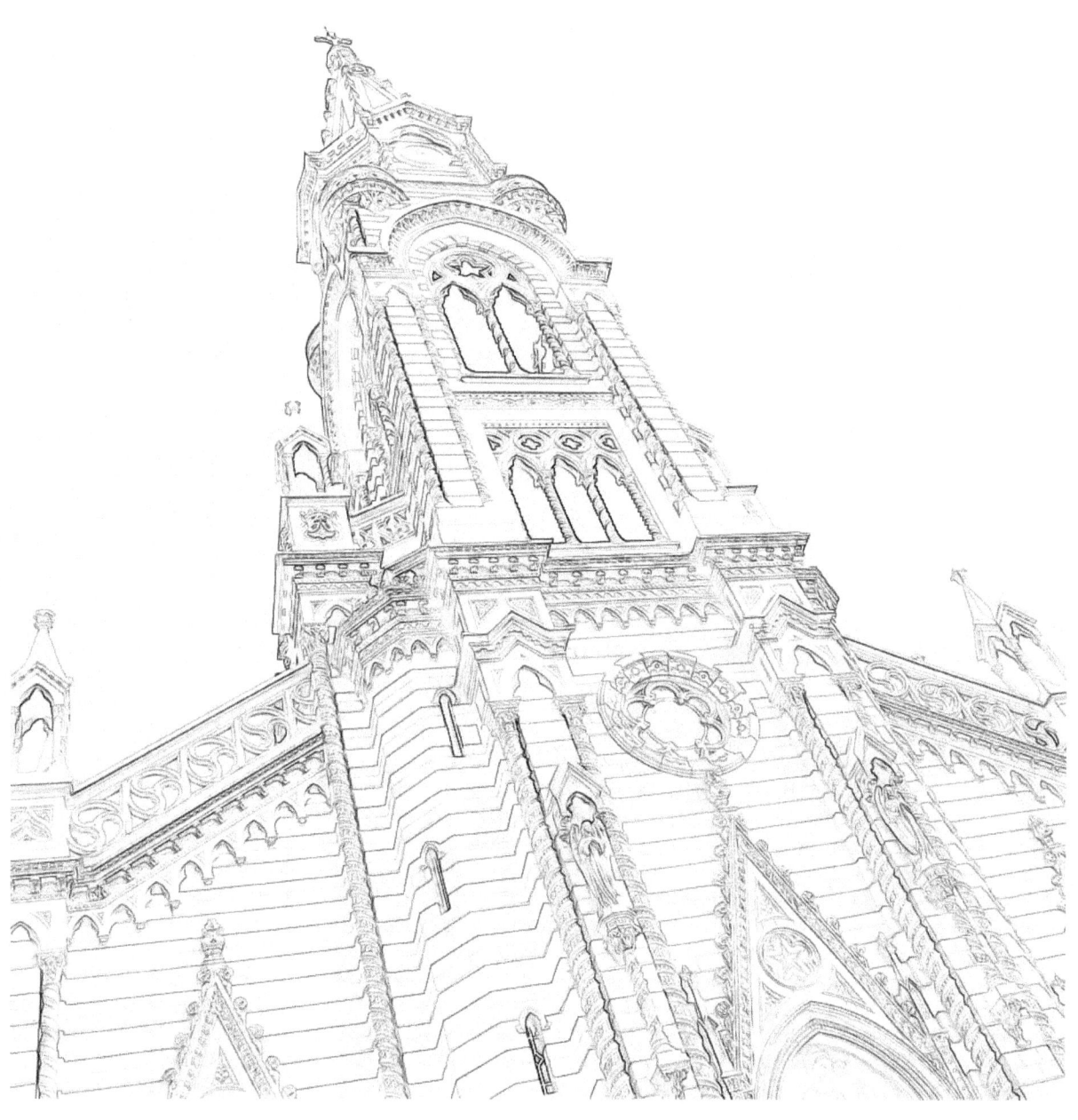

Low angle picture of a church facade in Bogota

Picture Guide for this book : http://bit.ly/colombia_best_2017
Don't Miss Another our Books.

http://bit.ly/good_vibes_1

ISBN : 1530381223
(Use this ISBN for searching on amazon.com)